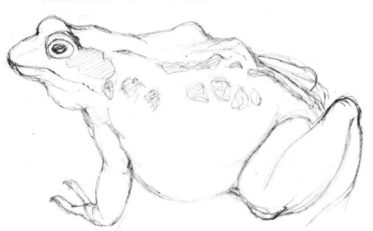

*Frog drawn in HB pencil.*

It is always desirable to draw from a living animal whenever you can; in spite of the difficulty of working from a model which moves before you have finished, the fragments that you do manage to get down have a conviction and truth to nature that will not be achieved without direct sight of the living animal.

The purposes for which drawings of animals can be used are as diverse as the drawings themselves; I may want to make a record of a particular activity; or to study a species of animal not always available; I may have in mind an illustration for which one animal is suitable, or feel that it will make a good picture for exhibition. I may want to do drawings for the purpose of studying, perhaps, movement or flight, or I may want to seize the opportunity of drawing the young of a particular species, preferably at different stages of development. These are all drawings done as a means to an end, but a drawing can also be an end in itself.

The quality of a drawing depends on the ability of the artist to look at the subject, to understand and analyse what he sees, both its form and its position in relation to his eye (its perspective), and to present the results of this concentrated study in physical form as marks on paper, or some other surface. It may be anything from the swiftest shorthand (a scribble on the back of an envelope) to a carefully considered, completely worked out exposition of form, detail and tone, conveying enough information to make a three-dimensional model

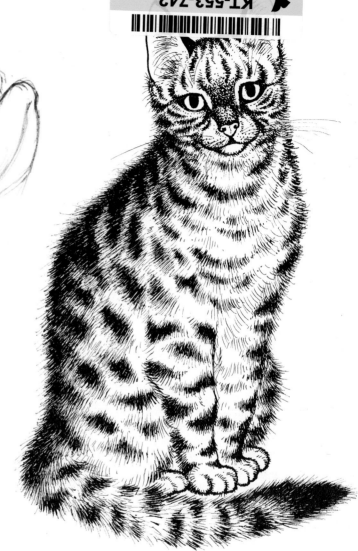

*Cat, in fine pen and black ink.*

from it. But do not work consciously towards developing a style; this must arise naturally from *your* way of working and seeing. A self-consciously applied style is merely a set of mannerisms. True style is often not apparent to the possessor of it, although he may perceive it in other artists' work, and others see it in his.

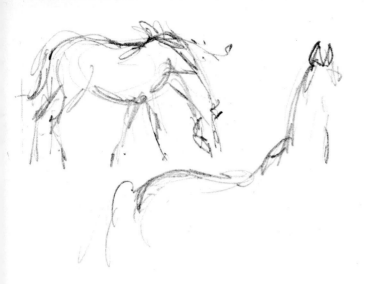

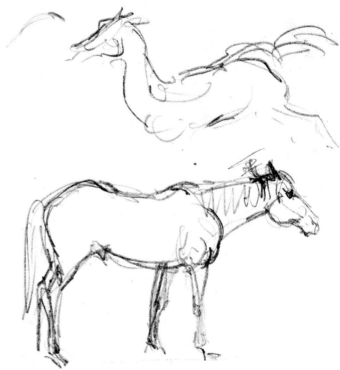

# Preparing to study your animal

If you have little experience of drawing animals, do not take on too formidable a task to start with; try to start with a sleeping subject. If you have a pet of your own, a cat or a dog, this should be easy enough; if not, perhaps a friend can be persuaded to prevent their cat from going out of the house for a while in order for you to draw it. If this cannot be managed there are few dwelling places where birds cannot be seen, as referred to on page 3, or attracted to one's garden or window-sill. Failing that, parks have frequently a large bird population, and usually a stretch of water with the larger waterbirds, often very tame and accustomed to the presence of people; in parks also there are usually dogs to be seen, though not necessarily for long, and squirrels, even, in some cases, deer. These however are not so likely to keep reasonably still as is a cat or dog in its own home.

However, it is a good idea to carry always a small sketchbook, which will fit into a pocket or handbag, and a pencil so that you can take advantage of any opportunity to draw that may occur. When drawing animals you must always be prepared to leave a sketch when the subject moves and to start another; do not succumb to the temptation to continue to same one, as this leads to anomalies of perspective and anatomy. Numbers of

*Quick studies of horses, in HB pencil.*

separate incomplete drawings are in fact, very useful; although each on its own is of limited scope they can in combination be used to build up a complete picture of the whole figure.

# Equipment

Very little is needed to start work with; a drawing board, paper and one or more media with which to draw.

**Drawing board:** this should be small and light, with rounded corners — a piece of 3-ply, about 15in. × 12in. (approx. 6 cm × 5 cm), and two or three bulldog clips — nothing is more irritating than paper being blown away while you are working.

**Paper:** start with white cartridge paper (for pencil or pen), or some other reasonably smooth paper, not too soft. Later on, be more adventurous, and try tinted and rough papers, for use with pastel, conté, watercolour etc.

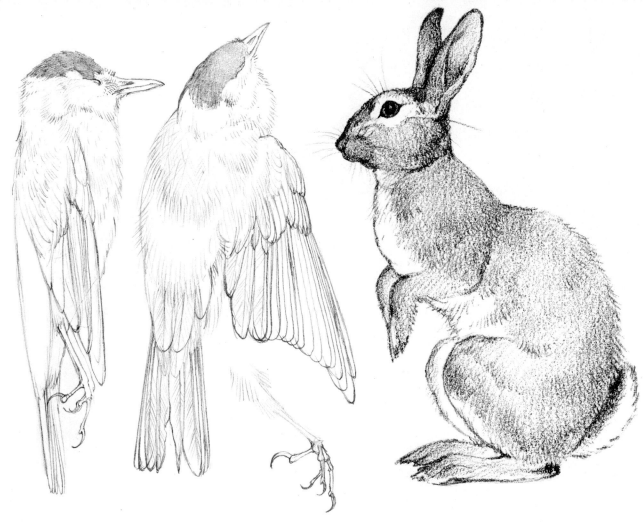

*Studies of dead blackcap, in H pencil.*

*Young rabbit, in 3B pencil.*

Sugar paper, Ingres, Canson — all have textures which can have a pleasant and enriching effect.

**Pencil:** my own preference is for the medium grades: B, HB, F, H or 2H, to draw fine precise detail; for a broader effect I find other media better. Try difference grades of pencil on each paper, as the same pencil will perform variably according to the surface.

**Crayons:** there is a very wide choice available; the 'coloured pencil' type is excellent and can be very precise. Wax crayon, either in pencil form or in sticks, is a most pleasing form. Conté crayon is very responsive, useful for broad treatment, and can be used in conjunction with pastel, or with pastel pencils. All of these are available in different colours: Conté in black, various browns, sanguine, grey and white, and in soft and harder grades; the others in a wide range of colours. All of these can be used attractively on tinted paper in different tones — black and white crayon on grey paper, for example, gives a most pleasing result.

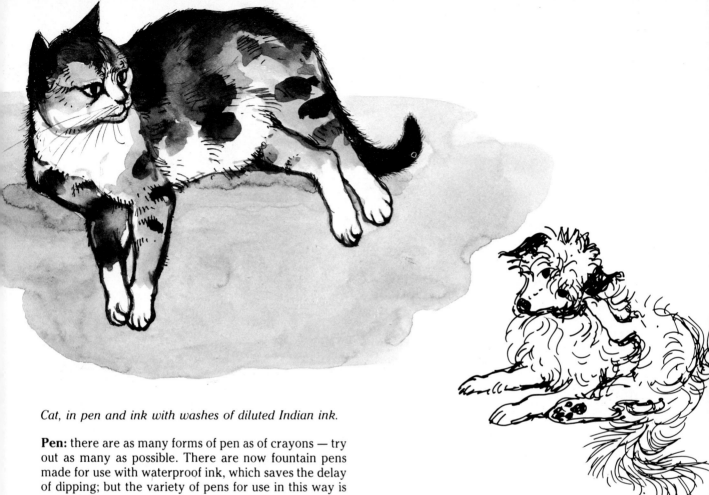

*Cat, in pen and ink with washes of diluted Indian ink.*

**Pen:** there are as many forms of pen as of crayons — try out as many as possible. There are now fountain pens made for use with waterproof ink, which saves the delay of dipping; but the variety of pens for use in this way is enormous, and they can give a crispness and liveliness of line unsurpassed by other forms. I use stylo pens in different sizes; they give a less variable line, but by using two or three in one drawing monotony of line is avoided. Ballpoint pen (black and fine for preference) is a pleasant and responsive tool, which slips swiftly over the paper to give its own very attractive quality, but I do not know of any make that will stand up to exposure to light; no ballpoint pen drawing should be framed or sold, but of course a light-fast reproduction could be made. Fibre tip pens are occasionally permanent and are bold and quick, but the colour bleeds on many papers.

**Brush:** drawings with watercolour or ink wash, either on its own or with pen, pencil or crayon line, open up a

*My dog scratching. A quick sketch executed in fine fibre-tip pen.*

huge field of varied uses and effects. Recommended for a quick rendering of a whole moving animal in the minimum number of strokes.

**Soft eraser:** (putty-rubber if you use conté or pastel), but do not over-use it — when drawing a moving animal it can be quicker and better to start again.

This is a formidable list of items to draw with, but you only actually need one of them; how many of the others you try is a matter of choice. The main thing is to find a medium that suits you.

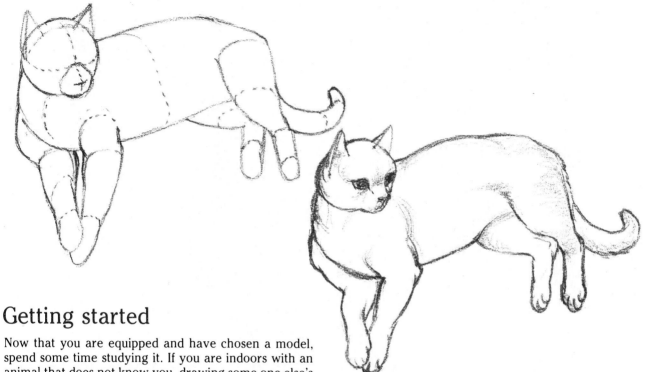

# Getting started

Now that you are equipped and have chosen a model, spend some time studying it. If you are indoors with an animal that does not know you, drawing some one else's pet for instance, let it get used to your presence before you begin to examine it. Animals dislike being scrutinized, particularly by a stranger. Talk to its owner for a while, so that it may watch you unobserved, get used to you, and see that its owner accepts you. When it seems ready, make friendly sounds to it, and pat or stroke it if it will let you. It is of great help when drawing an animal to be able to feel it gently, but don't try this unless you are sure the animal is ready for such familiarity.

When these overtures are completed, sit comfortably with your board and pencil, but not directly in its line of sight. (It is, of course, easiest to start with a sleeping animal.) Look at it, and decide what are the proportions of the main forms, and what their positions are in relation to you. The body first; look to see whether it is lying across your field of vision, or receding away from you, and if so, at what angle. Rough it in very lightly, then add the head and the limbs, using only the most generalised shapes; details can be added after the form and proportions are correctly worked out.

*Try to see the main forms of your animal, in order to establish proportion, after which add the features.*

Once the main structure is settled, more secondary forms can be added; the time spent on establishing the basic form correctly will ensure that anything added later in the way of details, patterns of hair growth and markings will be in their right places. You may leave out any details that seem unnecessary to the finished work; what is not permissible is to put in anything that is not there.

If the animal moves while you are working, and it is very likely to do so, you will have a number of incomplete details and half-drawn bits. This is normal and right. No drawing is ever wasted — each one of those incomplete pieces has contributed to the picture you will eventually finish, because by doing it you have discovered something about your subject; keep every line you have drawn, however insignificant it seems — it might later supply just the information you need.

7

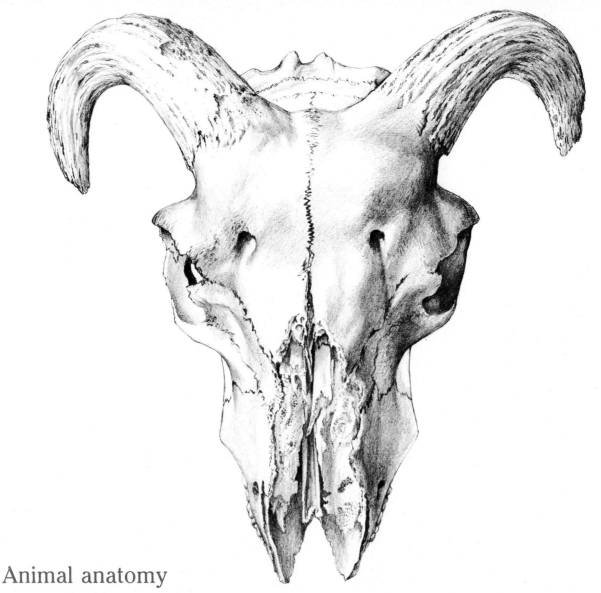

# Animal anatomy

It is helpful, when drawing an animal, to have some awareness of its anatomical structure, to supplement your observation. The structure of the vertebrate skeleton is not so very different from that of man; although the proportions are different, the bones of vertebrate animals, even of birds, are recognisable as the counterparts of those of man.

*Sheep's skull. A detailed study in H pencil. If you draw skeletons and skulls in museums, they will help you to understand the mechanism of animals.*

8

Most museums have some mounted skeletons of familiar animals, and it is worth looking at these and drawing one or two. You can then look with more understanding at the living animal; if you are able to handle it you will discover more about the way it fits together. Drawing mounted stuffed specimens can also be useful, for the study of proportions, and hair colour and growth, and will also help you to draw from live animals.

In much the same way, drawing from dead specimens, which one finds occasionally scarcely damaged on roadsides, can be of great value, particularly for careful exploratory drawings of details and general structure. It all adds to one's knowledge of the conformation of the creature, and in this case one can handle the animal and find out a great deal about it, which makes it possible to understand the form of the live moving animal when one has the opportunity of seeing it. I usually do such drawings in pencil, not too soft; a well-sharpened 2H, H, F or HB will give a clear fine sensitive line to define details of the structure of feet, ears, feathers, claws, beaks and growth-patterns of fur and plumage. Measurements and the scale of the drawings should also be recorded, and notes made about colouring. Such drawings of a blackcap appear on page 5.

Acquaintance with the anatomy of an animal will help you to understand movement; if you know where articulation occurs, you are more likely correctly to portray the posture of a moving animal. Try to analyse the movements of running animals, notice where the motion of a limb originates, and the extent of the movement as the animal moves at different speeds.

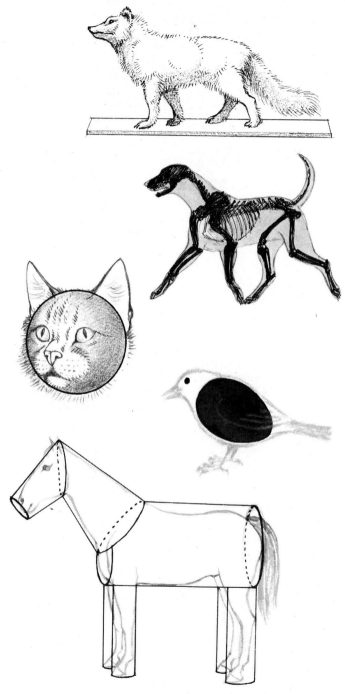

*From top to bottom: Arctic fox (stuffed specimen in museum); skeleton drawing of a running dog; a cat's face can be encompassed in a circle; a bird's body often resembles the egg from which it hatched; 'Blocks' superimposed on a horse drawing show the main forms.*

9

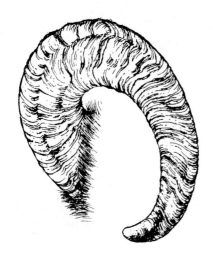

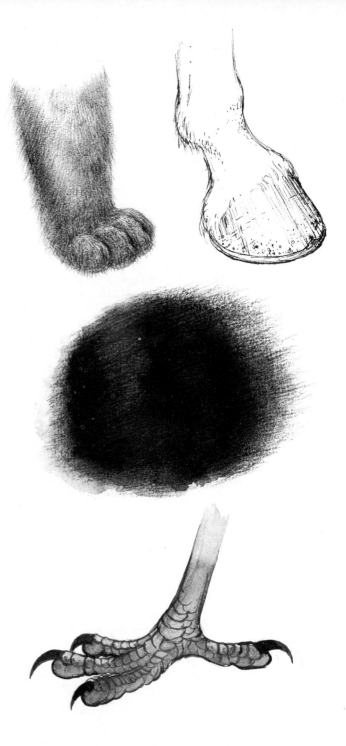

# Textures

There are many ways of conveying the varying textures of fur, horn, feathers, or eyes; some of them are illustrated on these two pages.

The thick transparent cornea of the cat's eye has been done with a very wet wash of black watercolour; when this is half-dry, I drop clean water in the centre from a large brush, which I then wipe dry and use to lift off the pigment from the middle of the eye, leaving a dark tone around the outside. This is allowed to dry thoroughly, and the fur, eyelids and pupil are then defined with a fine pen. The tone in the eye is enhanced with crayon, which I use to soften the edges of the fur and to give depth. White pastel provides extra brilliance.

The fish's eye requires a cooler tone to convey its thin, tinny character; here I use a 2H pencil and white pastel.

The feathers are done with thin crayon and conté crayon, with white pastel in each case for the shaft.

The sheep's horn, horse's hoof and crow's beak are drawn with pens, the bird's foot with brush and a wash of watercolour; the soft fur is in thin crayon over a watercolour wash; the dog's curly hair in white and grey conté crayon.

The fish scales are drawn with a fine fibre-tip pen, and white, grey and black pastel pencils are used over this.

The cat's paw is done with a very well-sharpened crayon, in many very light strokes.

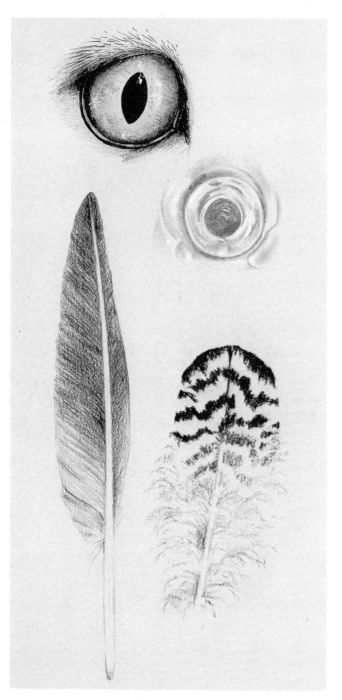

11

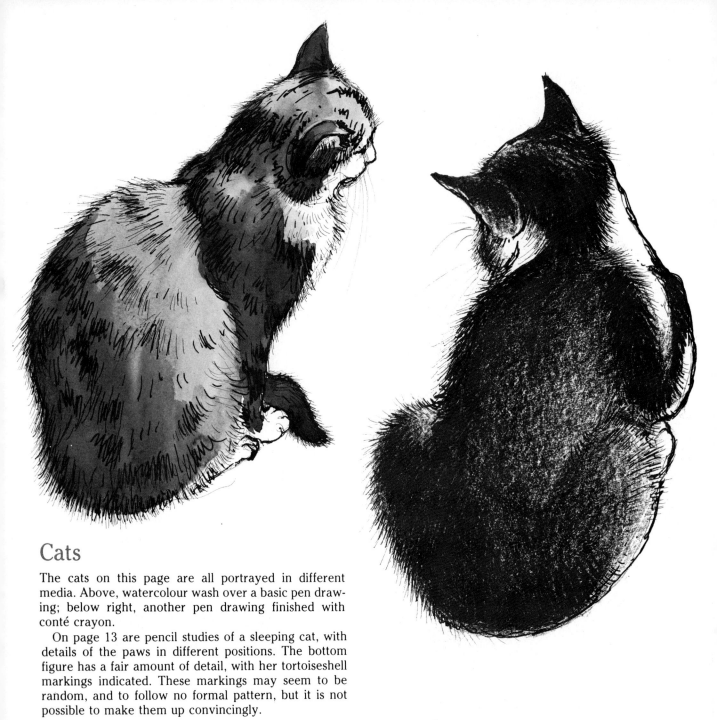

# Cats

The cats on this page are all portrayed in different media. Above, watercolour wash over a basic pen drawing; below right, another pen drawing finished with conté crayon.

On page 13 are pencil studies of a sleeping cat, with details of the paws in different positions. The bottom figure has a fair amount of detail, with her tortoiseshell markings indicated. These markings may seem to be random, and to follow no formal pattern, but it is not possible to make them up convincingly.

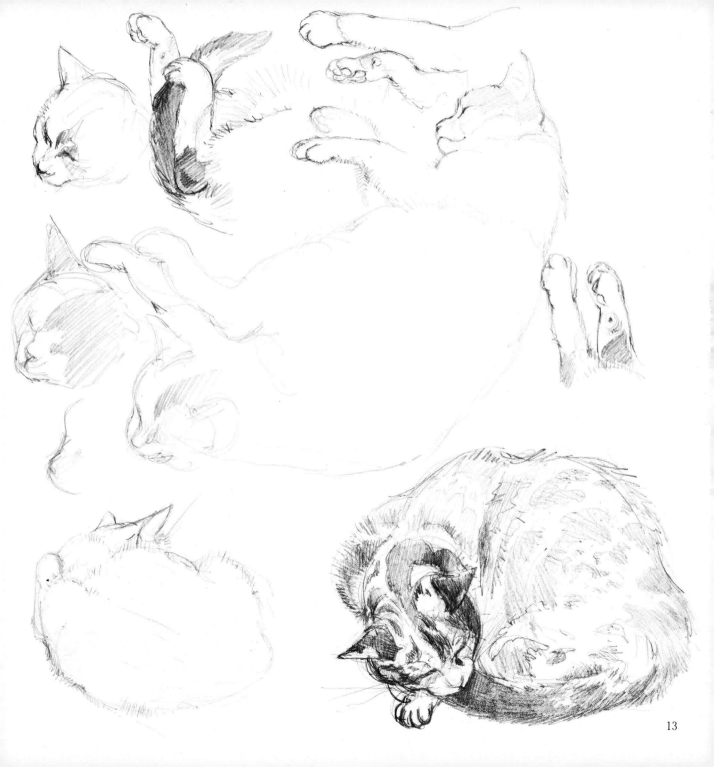

# Dogs

Animals have a wide range of expression, in spite of their lack of facial mobility. Moods and feelings expressed on a human face by means of movements of lips, eyebrows, cheek and forehead muscles, are shown by animals in movements of the head, ears, whiskers, tail, even the whole body. A cat's ears move forward when it is thinking about pouncing on something, as do those of tigers and lions. A cheerful dog expresses its mood with erect head and tail, and paws lifted high as it trots along; whereas a dog conscious of having done what it has been trained not to do expresses its contrition with equally telling body-language, grovelling with hanging head, rolling eyes, and tail between its legs.

The head of the dog on page 15, which is the same animal as in the ballpoint pen sketch below, shows how expressive a dog's eyes can be. The subtle, complex forms surrounding the eye need careful study; this is a young animal, but old enough to have lost the plumpness of infancy. Her face is comparatively bony, so that the forms of the skull show clearly through the skin.

I have made a number of sketches of her head from various viewpoints, and of details of her eyes and ears. The main drawing is done with a well-sharpened HB pencil. I find it necessary to sharpen the pencil frequently while working on a drawing of this sort. It makes a great difference to the sensitivity of the instrument.

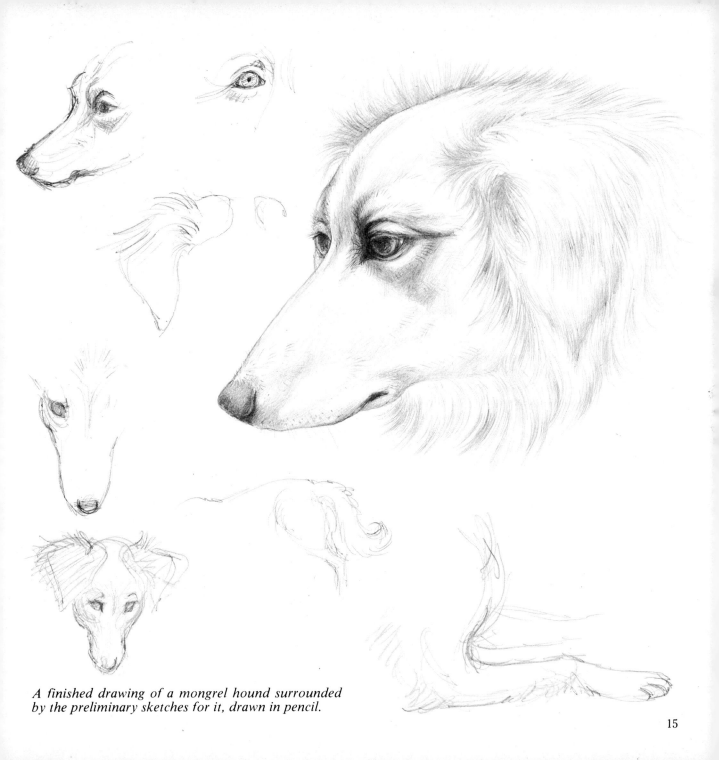

*A finished drawing of a mongrel hound surrounded by the preliminary sketches for it, drawn in pencil.*

15

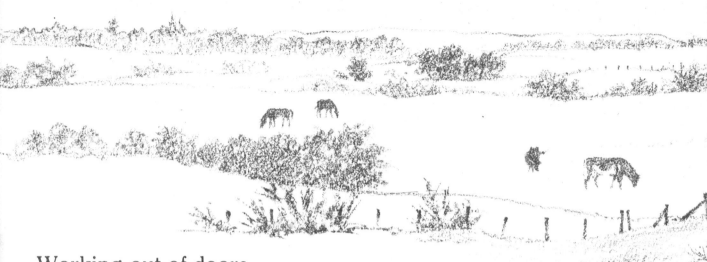

# Working out-of-doors

So far I have dealt principally with domestic pets. Outside the home there are many and varied animals to be found in different environments, both in town and country.

Working horses are rarer than they used to be, but a revival of interest in them has led to an increase in Horse Fairs which take place all over the world, where one may see Shires, Clydesdales, Suffolk Punches, all dressed up in ribbons and bells, groomed and polished to perfection. Sheep and cattle are to be seen in most rural localities — in spring in Kent sheep and lambs graze in orchards and churchyards as well as in the fields. Pigs are not so easily found out in the open, unfortunately; their coarse cheerful faces have considerable charm. Donkeys and goats nowadays are more commonly seen than for many years; herds of deer can be found in parks, and water-birds on rivers and pools.

*She-goat and her kids, drawn in B pencil.*

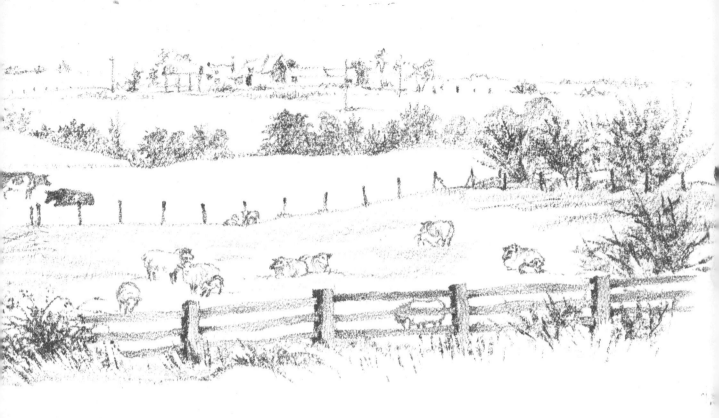

These can all be seen without going to zoos, where many more species are available, although their surroundings may leave something to be desired. However, the zoo parks and safari parks have brought about great improvements and are attempting to create something in the nature of an acceptable imitation of the animals' proper environment.

My equipment for working in either countryside, park or zoo is the same for it needs to be in as light and compact a form as possible. I usually take a small thin drawing board (with bulldog clips) in a light portfolio containing plenty of paper; and a hold-all for pencils, crayons, pens, knife and eraser; and sometimes a small watercolour box, a few brushes, a screw-topped jar of water, and rag or a few sheets of paper towel. If I work in a sketch book, I usually remove the drawings as they are done and put them into the portfolio, as they often get rubbed and spoiled when left in the sketch book. In any case all my drawings are filed into folders when I get home, according to species and breed.

I rarely take either a sketching easel or a folding stool for this kind of work, but reserve them for the occasions when I am working on landscapes. This is because one is bound to have to move about when drawing animals; it is essential to be free to follow one's subject in order to see it from a consistent viewpoint.

Working in the open gives opportunities for drawing animals at a distance; this forces one to sum up the character of the whole animal and its movements on a small scale yet without details.

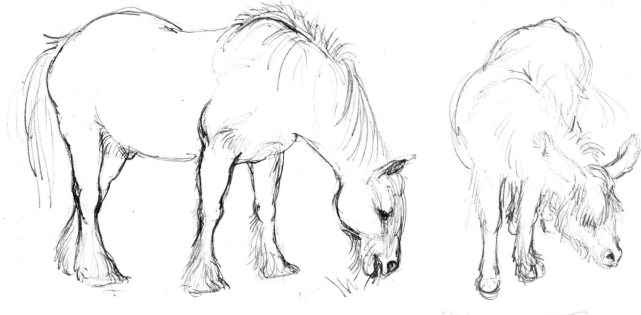

# Horses, ponies and donkeys

Drawing horses presents certain difficulties not encountered when working with other animals; they are the subject of great interest and devotion from many people, who have clear ideas about the desirable conformation of the animals and will be hypercritical of any pictures of them. A good accurate representation of a horse that does not match the ideal breed standard may be dismissed as a poor drawing, through a confusion of the ideal with actuality.

Some knowledge of these desirable standards is helpful in drawing horses; there is no substitute for observation, but knowledge makes for greater comprehension of what one sees, though one should be careful not to idealise.

Repeated and careful measuring is necessary when drawing anything; comparing the length of one part of an animal with another can give surprising results. Never be afraid to check such dimensions with a pencil held at arm's length. It is pleasant to have so accurate an eye that you can get the sizes right without the need to measure, but few of us are so blessed, and if it turns out that you have got it right, then no harm is done anyway! It is helpful to look at the spaces between the forms as well as at the forms themselves — this can tell you a

*Horse and donkeys, drawn in B pencil. Notice the heavier structure of the shire horse.*

great deal. Watch such matters as the position of a horse's eye, and ensure that it is placed sufficiently high in the head; study the shapes surrounding the eye, the size of the opening, the shape of the pupil, and how much of the eyeball shows outside the iris. So often, a reasonably good drawing of an animal is spoiled because these matters have been neglected, and the eye is too much like that of a human.

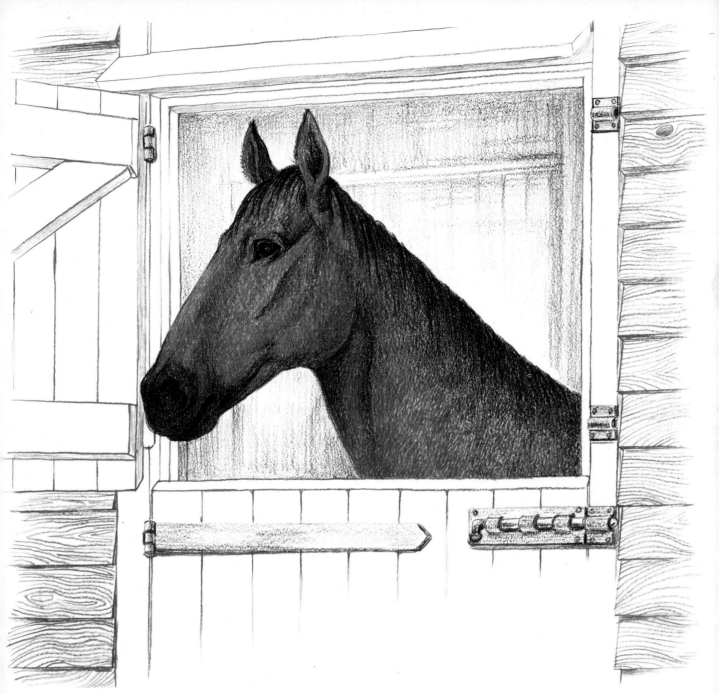

*Horse's head. A drawing in black and sepia conté.*

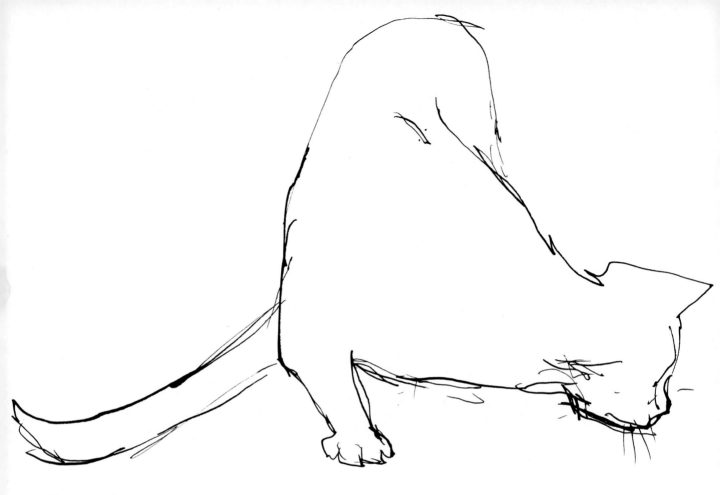

# Capturing movement

The difficulties of capturing the actions of animals as they leap, run, climb, play and stalk are such as to bring the artist to the verge of despair. The movements are so swift and sudden that there is hardly time to see the essential elements of the action, let alone to draw them.

My own method is to reduce the whole problem to a kind of shorthand; when, for instance, I want to draw a Margay mother and kitten flying around their cage chasing each other, I cover sheets of paper with curved lines which to me indicate the shapes assumed by their bodies and the position of legs, heads and tails. On their own these would be of limited usefulness, but by using them in conjunction with the more complete drawings I make

*I drew this lightning study of one of my cats, about to pounce, in pen and black ink. It took five seconds.*

when they are reasonably still, I am able to build up a picture of them in action.

I have to practise selecting the essence of the action and recording it quickly; the drawings are not impressive, but they are a kind of code, a reminder of what I saw for one second, and they serve to prompt my memory.

There is an excellent and most useful technique taught in certain Art Schools which is particularly helpful to artists drawing moving subjects; that is, the practice of

drawing continuously without taking one's eyes off the model, having trained one's hand to draw unwatched with reasonable accuracy. This is exactly what one needs when drawing from the many excellent natural history programmes on television, which often give only very brief glimpses of what one can otherwise rarely, if ever, see — healthy wild animals in their natural habitat. The slow motion sequences sometimes included in these programmes are invaluable.

*Margays at play. I made all these quick action studies while at the zoo; I was interested in capturing their movements, not in drawing detail.*

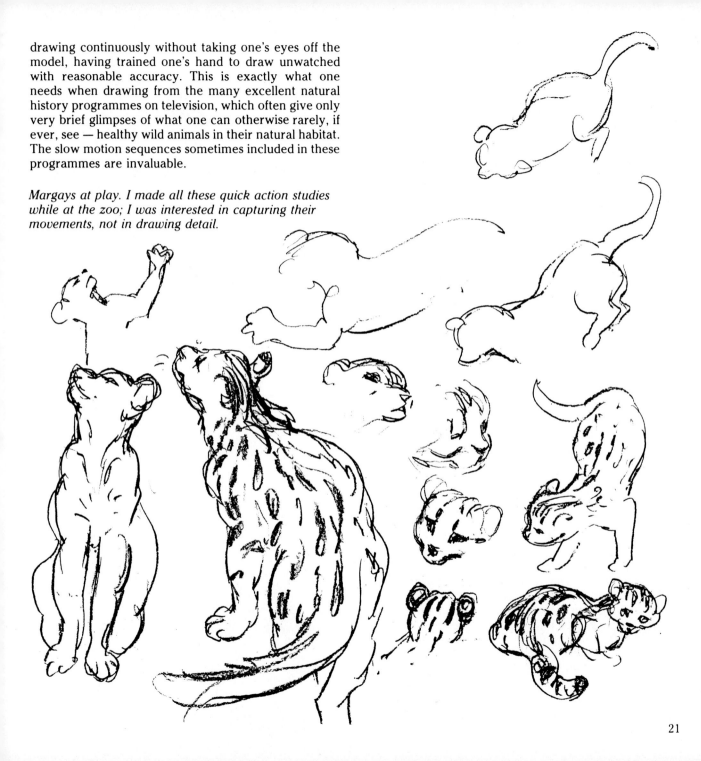

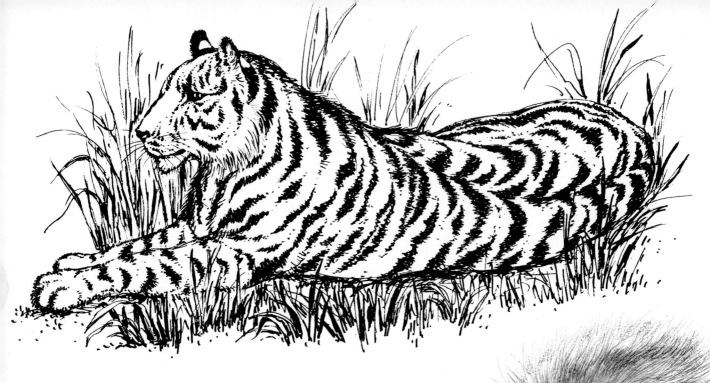

## Zoos and parks

Much of what has already been said in the sections on Working out-of-doors, Drawing horses, and Capturing movement, has a bearing on working in zoos and parks. The added factor here is the greater concentration of varied subjects to choose from, most of which are not easily seen elsewhere. Where do you start, and how much should you attempt? Is it better to draw as many different species as can be managed in the time, or to concentrate on one or two kinds for more detailed study?

If a trip to a zoo is a rare event for you, cover as much ground as you can comfortably manage; if you are likely to return before too long, choose a few interesting subjects, and do many drawings of each. You can then use these to prepare the foundation of a picture. You will probably have a number of incomplete animals and, details of heads, feet, ears, and markings, and a few slight sketches of the complete animal.

One of these can be chosen as the subject of the picture, and drawn, in the size and position required, lightly, on whatever paper, board or canvas you have chosen

22

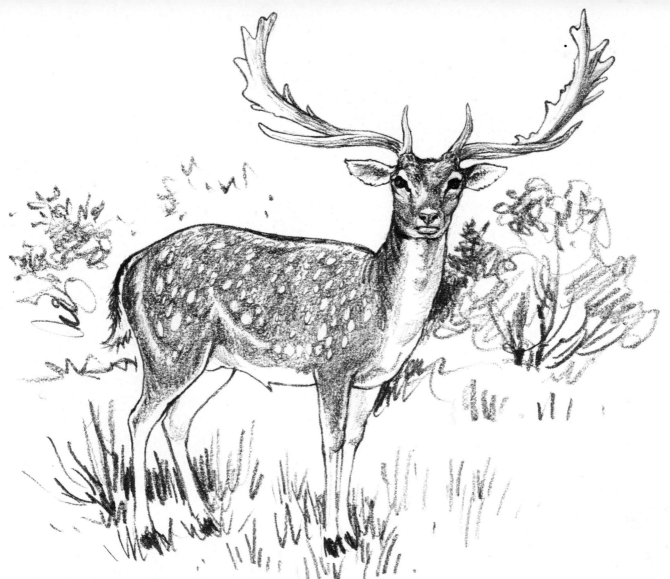

to work on. You then proceed, using all the other drawings of details, to lay in the figure of the whole animal, but keeping the whole light and open for further work to be done on it. Next time you visit the zoo, take this drawing with you, and with the animal before you, make adjustments and corrections where necessary.

Above
*Fallow deer. A finished study, showing its natural habitat, drawn in B pencil.*
Page 22:
*Siberian tiger, drawn with a fountain pen and black ink.*
Page 22:
*Squirrel, drawn with fine Rotring pen, and finished with diluted ink washes and touches of black crayon.*

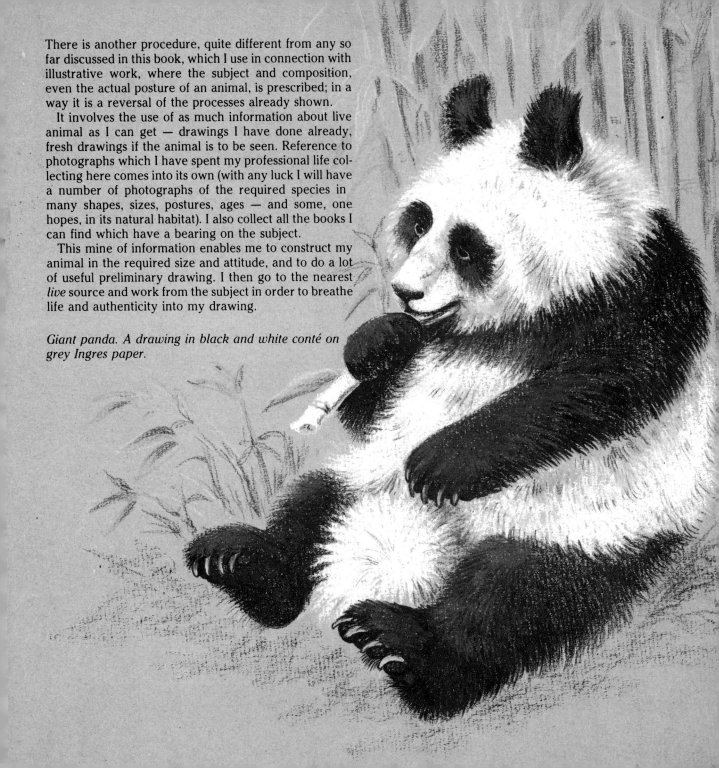

There is another procedure, quite different from any so far discussed in this book, which I use in connection with illustrative work, where the subject and composition, even the actual posture of an animal, is prescribed; in a way it is a reversal of the processes already shown.

It involves the use of as much information about live animal as I can get — drawings I have done already, fresh drawings if the animal is to be seen. Reference to photographs which I have spent my professional life collecting here comes into its own (with any luck I will have a number of photographs of the required species in many shapes, sizes, postures, ages — and some, one hopes, in its natural habitat). I also collect all the books I can find which have a bearing on the subject.

This mine of information enables me to construct my animal in the required size and attitude, and to do a lot of useful preliminary drawing. I then go to the nearest *live* source and work from the subject in order to breathe life and authenticity into my drawing.

*Giant panda. A drawing in black and white conté on grey Ingres paper.*

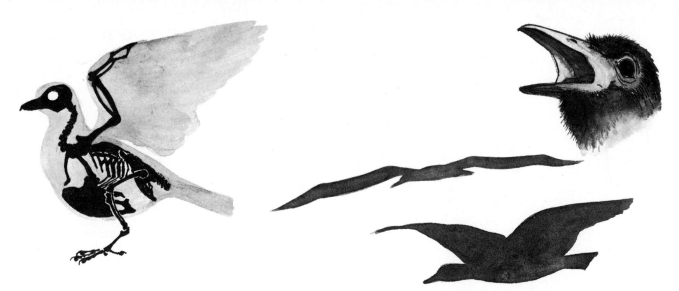

# Birds: anatomy

The diagram demonstrating how a bird's skeleton fits into its overall shape shows also that its skeleton has much in common with that of a mammal. The main bones are there, different in proportion, and with the breast-bone enormously enlarged and modified, but nevertheless the resemblance is clear.

Obviously flying is possible only if there are extremely strong muscles to move the wings; these muscles must therefore be attached to a structure sufficiently strong itself to withstand a great deal of pulling.

The proportions of wings to body vary in different kinds of bird to fit the requirements of each bird's way of life; condors, albatrosses, eagles — all large birds which soar and glide over great distances — have large long wings; the heavy deep-bodied geese and ducks need broad strong wings to enable them to take off from water; the small garden birds have more compact wings, shorter in proportion to their size.

The drawing of the open beak shows how, when the upper and lower mandibles separate, the fold of skin joining them forms a kind of gusset at the sides. Seen from in front, the width of a bird's open mouth is far greater than it looks to be from a side view.

Remember, birds are hatched from eggs: and even in maturity their bodies preserve to some extent the egg-shape from which they were hatched.

# Birds: in garden and home

Birds are to be seen almost everywhere in gardens, and even in great cities: sparrows, pigeons and starlings on windowsills; and many different varieties in parks and on commons. City birds are often extraordinarily tame and accustomed to people, and may give better opportunities for study than shy country birds.

Prolonged and thorough study of at least one species is possible to the owners of parrots, budgerigars, and canaries.

The illustration on page 26 is of an African grey parrot, and is drawn in white, grey, and black conté crayon/pastel on grey paper.

The bantam cockerel on page 27 is drawn in red conté crayon. The starlings around the bird table I drew mainly with a fine Rotring pen, although for the grass I preferred the thicker and more variable line of the fountain pen (which I used also for the Siberian tiger on page 22).

*African grey parrot. I drew this bird in black conté and pastel. I have also included a few of my preliminary sketches which were made in fine pen and black ink.*

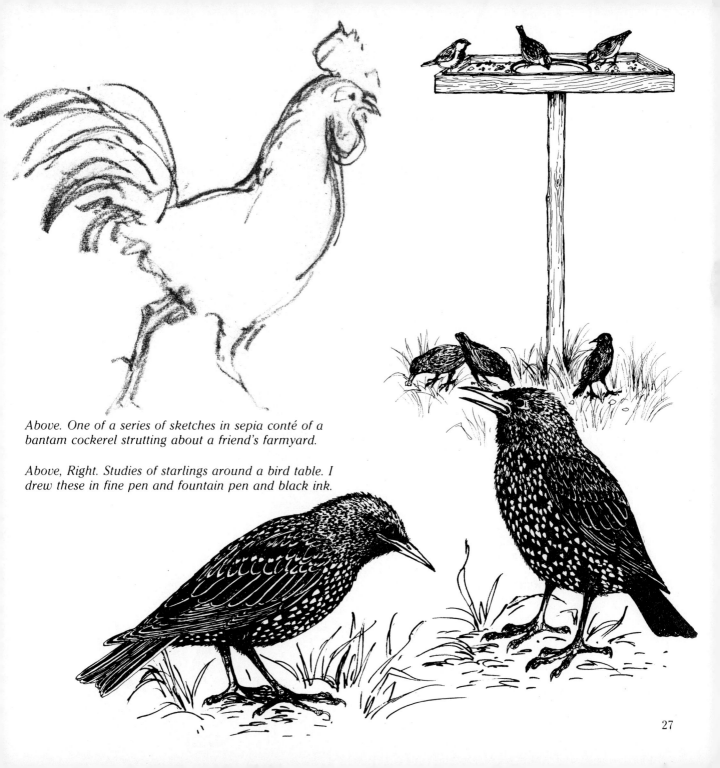

*Above. One of a series of sketches in sepia conté of a bantam cockerel strutting about a friend's farmyard.*

*Above, Right. Studies of starlings around a bird table. I drew these in fine pen and fountain pen and black ink.*

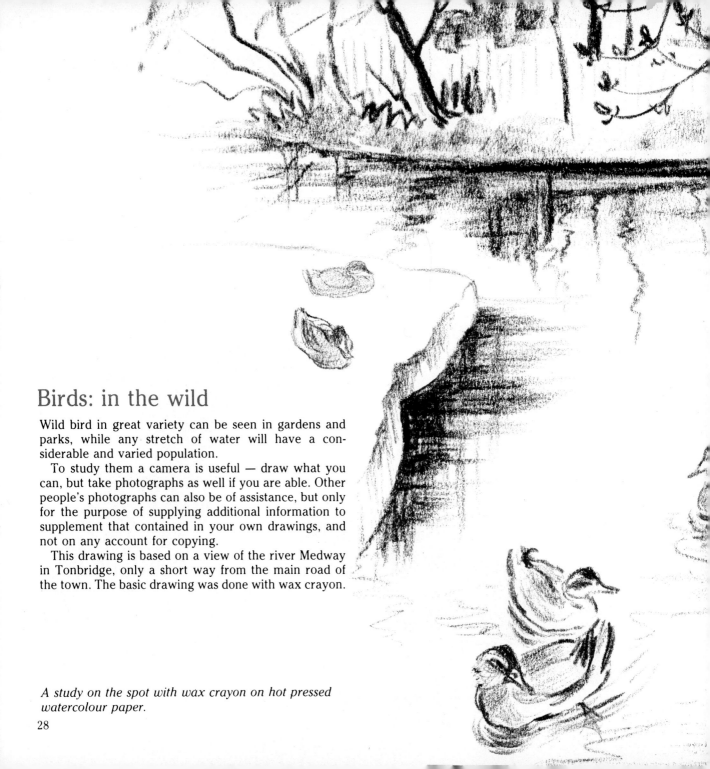

# Birds: in the wild

Wild bird in great variety can be seen in gardens and parks, while any stretch of water will have a considerable and varied population.

To study them a camera is useful — draw what you can, but take photographs as well if you are able. Other people's photographs can also be of assistance, but only for the purpose of supplying additional information to supplement that contained in your own drawings, and not on any account for copying.

This drawing is based on a view of the river Medway in Tonbridge, only a short way from the main road of the town. The basic drawing was done with wax crayon.

*A study on the spot with wax crayon on hot pressed watercolour paper.*

29

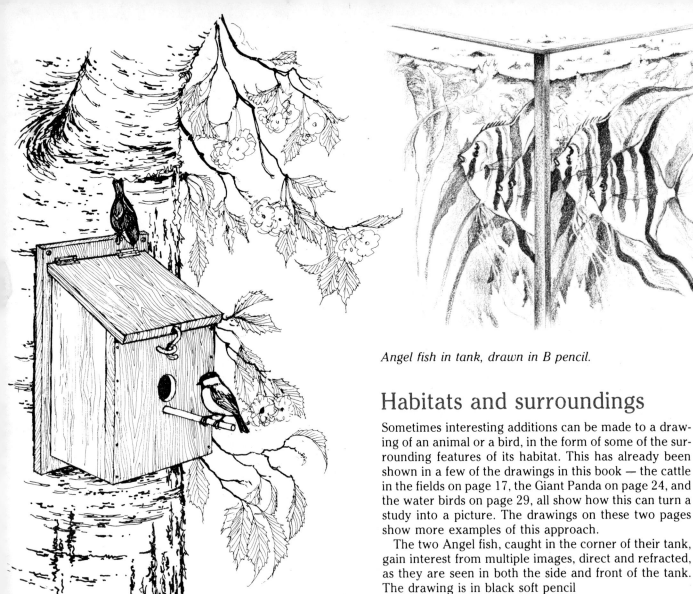

*Angel fish in tank, drawn in B pencil.*

# Habitats and surroundings

Sometimes interesting additions can be made to a drawing of an animal or a bird, in the form of some of the surrounding features of its habitat. This has already been shown in a few of the drawings in this book — the cattle in the fields on page 17, the Giant Panda on page 24, and the water birds on page 29, all show how this can turn a study into a picture. The drawings on these two pages show more examples of this approach.

The two Angel fish, caught in the corner of their tank, gain interest from multiple images, direct and refracted, as they are seen in both the side and front of the tank. The drawing is in black soft pencil

Artificial nesting boxes both attract and protect small birds. Including the box in the drawing of the blue tits gives scale to the birds and interest to the composition, which is carried out with stylo pens in three sizes.

The seagull, perched on the mast, is a familiar symbol — not particularly original, but a cheerful reminder of summer. This drawing is in black, white, and very dark grey pastel on light grey paper.

*Nesting box with blue tits, drawn with a fine Rotring pen and black ink.*